CLEAN SAILS

TYPEWRITER POEMS
FROM THE SUN
PARLOUR OF CANADA

gustave morin

NEW STAR BOOKS

MMXV

other works by gustave morin

rusted childhood memoirs (1994)
sun kissed oranges (w/ Sergio Forest (1995)
p.mody's dada boutique (1997)
a penny dreadful (2003)
the etcetera barbecue (2006)
79 little explosions & Q-bert stranded on a smouldering mosquitocoil frozen to a space formerly occupied by language (2009)
sucker (2009)
rare sheet music (2010)
a psychowestern (2010)
zoot suitcase (2012)
the elephant papers (2014)

In memory of

William D. Schneider

1921 : 1994

&

Betty Kelly *nee* Canfield

1926 : 2008

Clean Sails — Table of Contents

frontis
cilents # one
other works by …
cilents # two
dedication
cilents # three

(table of contents)

cilents # four

water

Clean Sails

part one …

dial d for dial
desiderata
sugar and the whip antenna
filet-o-snap
rated r
culvert
just checking your holes for pockets
jolly roger
the unauthorized formation of the third line
the pearl
pinchbeck
typo negative
crime as ornament
the doggerel diamond
period piece
school of hard nocturne
bauhaus arrest
any colour you like as long as its blacklisted
between terminal velocity and the flames we acquire speech
gnashvil
mimeo killed the radio scar
glass blizzard

haiku
swarm leatherette
abyss for dessert
entropy wires
reciprocal snares
horseshoes for cloven hooves
file under thirteen
small fry
argosy changes
the escargot regatta
the pavement under the beach
tunnel canaries
jettisonar
side show à la carte
a brittle gidouille
friday night at cedar and locust
charivari
a tin eye toke
½ a loaf is better than no bread
the dead blank of the black skeleton in the blinding square
briquet
the wringer
beating and nothingness
janelo negro
stained glass origami
what anonymity does not pay in prestige it makes up for in stealth
the eggshell waltz
thug carpet (for dfb
the stinging loom
venom de plume
koan
google search
33 blind mice
quarantine
reptile house
a jewel for pirate jenny

water 〜〜〜〜〜〜〜〜〜〜〜〜〜〜〜〜〜

monolith (intro)

entr ' acte — nein typos (2008)

at muck in ur may lurk much murk
a unique has no name
factoria
sketch for scrapheap
the incessant drip
the ludicrous snowman
depthsounding
locust poles
trans

monolith (outro)
water

part two …

dog fucking by barney rubble
knill
knull
new waves
rime
sonnet
the lyrical vain
the unremarketable starvelings
chopt liver (for uu
wooden nichols (for jwc
lint in a gale
the bigbox tidalwave
motorcade
vespers of the grey slush
the gizzard of flaws
cabin fever
flea circus
matinée idle
shattered idols by edward sloman
the yellow line through the blue movie
the table movies
papa kino
21st century hamburger
potato

pyramid scheme
limo across the chasm
a thousand cuts
400 dada suicides blow 200 motel hellos
murder ballad
blood on the mudflap
vortext
the hive
a(f)front
the rhomboid panhandle
ziggurat bastard
cement shoes
the polkadot apocalypse
no editor will ever drink champagne from my skull
the abandoned tor
the dark fantastic
the husky lozenge
ghettoblaster
figure eight
fragment from a player piano scroll, of unknown origin
zaumnet
chimera
nothing is new except what has been forgotten
the bones in the wane museum
statue of limitations
photo finished
escape from albatross
hard-boiled confetti
set sail today for further fathoms tomorrow

the witch patch of ghent

(...)

notes
dramatis personae
konfessions of an expanded typewriter poet
cilents # five
when birds turbine, knacker squirms — a note on concrete poetry
cilents # six
acknowledgements
new star books colophon
author note

clean sails

gustave m.

I have given up on writing about people, places, things …

— **Alexander Skippy Spence**

Part One /

desiderata

sugar and the whip antenna

filet – o – snap

Rated R

culvert
=========

just checking your holes for pockets

jolly roger

The Unauthorized Formation of the Third Line

The Pearl

Pinchbeck

typo negative

crime as ornament
=================

the doggerel diamond

period piece

school of hard nocturne

Bauhaus Arrest

any colour you like as long as its blacklisted

between terminal velocity & the flames we acquire speech

———————————————————————————— Gnashvil ————————————————

mimeo killed the radio scar

glass blizzard

haiku

---------------------------------*Swarm Leatherette*

Abyss for Dessert

entropy wires

reciprocal snares

HoRSESHoES FoR CLoVEN HooVES

file under thirteen

small fry

```
            -
         - ᵕ - ᵕ -
      ᵕ - ᵕ - ᵕ - ᵕ
      ᵕ - ᵕ - ᵕ - ᵕ
      ᵕ - ᵕ - ᵕ - ᵕ
      ᵕ - ᵕ - ᵕ - ᵕ
         ᵕ - ᵕ - ᵕ -
            ᵕ   ᵕ
```

Argosy Changes

the escargot regatta

The Pavement under the Beach

tunnel canaries

Jettisonar

side show a la carte

A Brittle Gidouille

:::::::::::::::::::: Friday Night at Cedar & Locust

Charivari

a tin eye toke

½ a loaf is better than no bread

the dead blank of the black skeleton in the blinding square

Briquet

the wringer

beating and nothingness

janela negro

Stained Glass Origami

what anonymity does not pay in prestige it makes up for in stealth

The Eggshell Waltz

Thug Carpet ---------------------- *for dfb*

The Stinging Loom

Venom de Plume

koan

Google Search

33 blind mice
===============

Quarantine
============

Reptile House

/ Entr'Acte /

NEIN TYPOS

```
------------------------------------
  at muck in ur may lurk much murk
------------------------------------
```

A unique has no name

factoria

sketch for scrapheap

the incessant drip

(a fragment)

The Ludicrous Snowman

depthsounding

Locust Poles

::::::TRaNS::::::
(for the few

Let death and exile and every other thing which appears dreadful be daily before your eyes; but most of all death: and you will never think of anything mean nor will you desire anything extravagantly.

— **Epictetus**

/ Part Two

knill
-=-=-=-=-=-=-=-

knull

new waves

RIME

S O N N E T

The Lyrical Vain

The Unremarketable Starvelings

Chopt Liver
........................
--------------- for UU

wooden nichols
::::::::::::::::for jwcurry:::
-=-=-=-=-=-=-=-=-=-=-=-=-

Lint in a Gale

The Bigbox Tidalwave

motorcade

vespers of the grey slush

the gizzard of flaws

cabin fever

Flea Circus

matinee idle

Shattered Idols by Edward Sloman
===================================

/////////// the yellow line through the blue movie ///////////////////

The Table Movies

Papa Kino

21st Century Hamburger

POTATO
....................

Pyramid Scheme

Limo Across The Chasm

a thousand cuts

400 dada suicides blow 200 motel hellos

murder ballad

Blood on the Mudflap

vortext

```
zzzzzzzzzzzzzzzzzzzzzzzzzzzzzzzzzzzzzzzzzzzzzzzz
zyyyyyyyyyyyyyyyyyyyyyyyyyyyyyyyyyyyyyyyyyyyyyyz
zyxxxxxxxxxxxxxxxxxxxxxxxxxxxxxxxxxxxxxxxxxxxxyz
zyxwwwwwwwwwwwwwwwwwwwwwwwwwwwwwwwwwwwwwwwwwxyz
zyxwvvvvvvvvvvvvvvvvvvvvvvvvvvvvvvvvvvvvvvvvwxyz
zyxwvuuuuuuuuuuuuuuuuuuuuuuuuuuuuuuuuuuuuuvwxyz
zyxwvuttttttttttttttttttttttttttttttttttttuvwxyz
zyxwvutsssssssssssssssssssssssssssssssssstuvwxyz
zyxwvutsrrrrrrrrrrrrrrrrrrrrrrrrrrrrrrrrrstuvwxyz
zyxwvutsrqqqqqqqqqqqqqqqqqqqqqqqqqqqqqqqrstuvwxyz
zyxwvutsrqppppppppppppppppppppppppppppppqrstuvwxyz
zyxwvutsrqpooooooooooooooooooooooooooooopqrstuvwxyz
zyxwvutsrqponnnnnnnnnnnnnnnnnnnnnnnnnnnopqrstuvwxyz
zyxwvutsrqponmmmmmmmmmmmmmmmmmmmmmmmmnopqrstuvwxyz
zyxwvutsrqponmllllllllllllllllllllllmnopqrstuvwxyz
zyxwvutsrqponmlkkkkkkkkkkkkkkkkkkkklmnopqrstuvwxyz
zyxwvutsrqponmlkjjjjjjjjjjjjjjjjjjjklmnopqrstuvwxyz
zyxwvutsrqponmlkjiiiiiiiiiiiiiiiiijklmnopqrstuvwxyz
zyxwvutsrqponmlkjihhhhhhhhhhhhhhhijklmnopqrstuvwxyz
zyxwvutsrqponmlkjihgggggggggggghijklmnopqrstuvwxyz
zyxwvutsrqponmlkjihgffffffffffghijklmnopqrstuvwxyz
zyxwvutsrqponmlkjihgfeeeeeeeefghijklmnopqrstuvwxyz
zyxwvutsrqponmlkjihgfedddddddefghijklmnopqrstuvwxyz
zyxwvutsrqponmlkjihgfedccccdefghijklmnopqrstuvwxyz
zyxwvutsrqponmlkjihgfedcbbbcdefghijklmnopqrstuvwxyz
zyxwvutsrqponmlkjihgfedcbabcdefghijklmnopqrstuvwxyz
zyxwvutsrqponmlkjihgfedcbbbcdefghijklmnopqrstuvwxyz
zyxwvutsrqponmlkjihgfedccccdefghijklmnopqrstuvwxyz
zyxwvutsrqponmlkjihgfedddddddefghijklmnopqrstuvwxyz
zyxwvutsrqponmlkjihgfeeeeeeeefghijklmnopqrstuvwxyz
zyxwvutsrqponmlkjihgffffffffffghijklmnopqrstuvwxyz
zyxwvutsrqponmlkjihgggggggggggghijklmnopqrstuvwxyz
zyxwvutsrqponmlkjihhhhhhhhhhhhhhhijklmnopqrstuvwxyz
zyxwvutsrqponmlkjiiiiiiiiiiiiiiiiijklmnopqrstuvwxyz
zyxwvutsrqponmlkjjjjjjjjjjjjjjjjjjjklmnopqrstuvwxyz
zyxwvutsrqponmlkkkkkkkkkkkkkkkkkkkklmnopqrstuvwxyz
zyxwvutsrqponmllllllllllllllllllllllmnopqrstuvwxyz
zyxwvutsrqponmmmmmmmmmmmmmmmmmmmmmmmmnopqrstuvwxyz
zyxwvutsrqponnnnnnnnnnnnnnnnnnnnnnnnnnnopqrstuvwxyz
zyxwvutsrqpooooooooooooooooooooooooooooopqrstuvwxyz
zyxwvutsrqppppppppppppppppppppppppppppppqrstuvwxyz
zyxwvutsrqqqqqqqqqqqqqqqqqqqqqqqqqqqqqqqrstuvwxyz
zyxwvutsrrrrrrrrrrrrrrrrrrrrrrrrrrrrrrrrrstuvwxyz
zyxwvutsssssssssssssssssssssssssssssssssstuvwxyz
zyxwvuttttttttttttttttttttttttttttttttttttuvwxyz
zyxwvuuuuuuuuuuuuuuuuuuuuuuuuuuuuuuuuuuuuuvwxyz
zyxwvvvvvvvvvvvvvvvvvvvvvvvvvvvvvvvvvvvvvvvvwxyz
zyxwwwwwwwwwwwwwwwwwwwwwwwwwwwwwwwwwwwwwwwwwxyz
zyxxxxxxxxxxxxxxxxxxxxxxxxxxxxxxxxxxxxxxxxxxxxyz
zyyyyyyyyyyyyyyyyyyyyyyyyyyyyyyyyyyyyyyyyyyyyyyz
zzzzzzzzzzzzzzzzzzzzzzzzzzzzzzzzzzzzzzzzzzzzzzzz
```

The Hive

A(F)FRONT

the rhomboid panhandle

ziggurat bastard

cement shoes

the polkadot apocalypse

no editor will ever drink champagne from my skull

the abandoned tor

the dark fantastic

the husky lozenge

ghettoblaster

the quick brown fox jumps over the lazy dog.

figure eight

ORIGIN

UNKNOWN

OF

SCROLL ,

PIANO

PLAYER

FROM A

FRAGMENT

Zaumnet

chimera

Nothing is new except what has been forgotten

The Bones in the Wane Museum

statue of Limitations

Photo Finished

escape from albatross

hard-boiled confetti
-=-=-=-=-=-=-=-

set sail today for further fathoms tomorrow

o o o

********************** notes **********************

part one... .//. alexander 'skippy' spence (1946 : 1999); (not so) arguably the most important artist ever born at windsor, ontario. oar, his solitary solo 1969 recording, is an undeclared masterpiece.

desiderata .//. a trendy word, used at the behest of witold gombrowicz (1904 : 1969); something wanted or needed which (as quite often in these cases) also cannot be found.

filet-o-snap .//. cf. let's dance, c. 1962, by chris montez (b. 1943); rowdy but fun.

jolly roger .//. cf. marcel broodthaers (1924 : 1976) channeled through robert louis stevenson (1850 : 1894)

small fry .//. cf. fisches nachtgesang (1905) by christian morgenstern (1871 : 1914); the most beautiful piece of silence a human has ever recorded, and the only predecessor the poems in this book required. translation mine.

jettisonar .//. nonce word, perhaps. possible portmanteau word in disguise. one of several in the book ...

a brittle gidouille .//. the go-to symbol for 'pataphysics, 'the science of imaginary solutions' as handed down by alfred jarry (1873 : 1907); a.k.a. french for swirl.

friday night at cedar & locust .//. cf. bug death (1979) but especially, ecosystems collapsing (1992) by terminally underrated american poet f.a. nettelbeck (1950 : 2011), now basking in eclipse. pure coincidence that the abstract expressionists used the cedar as their hole in the wall, too.

charivari .//. unfortunately, a poem about unrequited lust.

dead blank, etc. .//. cf. aesthetics after modernism (1983) by peter fuller (1947 : 1990); an huge essay.

janela negro .//. black window in brazilian portuguese. translation mine.

thug carpet .//. dfb = daniel f. bradley, (b. 1964); underrated canadian poet, lives in toronto.

reptile house .//. cf. sisters of mercy c. 1983, via leonard cohen (b. 1934) via a.m. klien (1909 : 1972)

monolith .//. cf. danielle collobert (1940 : 1978); french author, poet & journalist. her 1976 book il donc (it then) is perhaps the single scariest volume of poetry ever written.

new waves .//. waves as in plural. count them; we like them all.

chopt liver .//. uu = david uu (1948 : 1994); major first waver of canadian concrete poets, currently basking in eclipse. an entire poetics so called could be cobbled out of 6 or 7 various of his more extraordinary poems.

wooden nichols .//. cf. bpnichol (1944 : 1988); if a canadian concrete poet needed no introduction, it is he. 'nuff said. jwcurry (b. 1959); canadian poet who is very likely more of a polymath than bp was, though lesser known.

shattered idols, etc. .//. 1922 silent film directed by edward sloman (1886 : 1972); rumoured to be a masterpiece, now lost to posterity. as apt a metaphor for the fate of all our creations as any ...

the table movies .//. cf. bill bissett (b. 1939) (and his many typewriters across his restless passage; perhaps the very ones kerouac coveted). see also th mandan massacre, 1967; cf. d.a. levy (1942 : 1968), et al ...

ghettoblaster .//. cf. willard s. bain's 1967 undeclared masterpiece, informed sources.

zaumnet .//. pseudo-nonce word; zaum and sonnet. zaum = russian nonce word for transrational thinking.

Dramatis Personae

Volker Nix — underwood 6/12, made in canada
Monica — olympia 'monica', made in west germany
Linea — olivetti 'linea 88', made in canada
The Hebe — hebrew / aramaic remington rand, made in canada
The Five — underwood 'touchmaster number 5', made in canada
Vendex — vendex, made in italy
Heli — smith corona 'classic 12', jewelled, made in canada
Zil — smith corona 'classic 12', unjewelled, made in canada
Noah Loure — underwood 315 (cursive), made in spain
Cy Machina — underwood 315 (standard), made in spain
The Tooth Courier — smith corona 'courier', made in england
Safari — royal 'safari', made in u.s.a.
Bulldog — olivetti 'studio 44', made in canada
Ruskie — an olympia russian cyrillic brought to chicago from the ukraine in a wooden box, possibly west german ?
Kundu — litton / royal 200, made in u.s.a.
Hector Wheat-Gomez — underwood 378, made in spain
Legba One — olympia 'de luxe', made in west germany
Legba Two — scm 'zephyr 2', made in england
Super G — smith corona 'ghia design super g', made in england
Nils Wombwell — olivetti 'ms 25 premier plus', made in china !
Orizaba — royal 'quiet de luxe', made in canada
Mod Con — commodore 2200, made in canada
Huw Tumulty — olivetti underwood 'lettera 32', made in canada
Tuffy — remington ?, made in canada

dead or otherwise deacquisitioned from the arsenal

smith corona 'coronet classic 12', made in canada
smith corona 'coronet automatic', made in u.s.a.
brother 'profile electric 12', made in japan
sears 'celebrity electric 10', made in japan
remington 'quiet riter', made in england
brother 'ax-250 electronic typewriter', made in japan
smith corona 'electra 220', made in canada
smith corona 'enterprise xt', made in u.s.a.
olympia 'electronic compact', unrecorded …
a destroyed smith corona …
some forgotten roommate's typewriter, unrecorded

thanks to Milan Tofiloski, Stephanie Beno, Bernie Helling, Julie Sando, Sergio Forest and especially to Randy Diestelmann (X 2!) for donating machines to the arsenal. mr. g is still searching for a few unusual, exotic and/or foreign language typewriters, which are never easily located. anyone wishing to make a donation to this arsenal for future installments of this project is kindly requested to contact the author care of this publisher.

/ Konfessions of an Expanded Typewriter Poet /

i first became interested in the typewriter back in 1982, when, as a very young chap, i accompanied my mother to her secretarial course and was exposed to their existence. i'd sit by myself at the back of a classroom filled with typewriters, just smacking away at the keys of the machine i sat in front of, fascinated that with every hit of every key an instant tangible result was produced. cause and effect were never made more manifest!

by 1987 i had spotted the work of Dom Sylvester Houédard (1924 : 1994) — my own, private, patron saint of typewriters, (henceforth referred to as dsh, his preferred moniker) — in the *oxford book of 20th century poetry & poetics* (1973). though i was still a few years away from the beginning of my lifelong love affair with concrete poetry, i knew then, seeing dsh's work for the first time, that it had been made on the typewriter. duly impressed i was, and something must've stuck with me. at the time, one of my so called educators had recently seen fit to flunk me in my own typing 101 course that very year. given the demands of this project and the time its taken me to arrive at this point, it still seems incredible to me now to think that i sat in a typing class every day for a full year and at the year's end i did not receive credit. but a short while later i was to be flunked in art, and then later still not accepted into entry level creative writing courses either, and though neither of any of those obstacles could at those times be taken lightly, they have come to serve me well in the long run, where it really counts …

i first sat down to a typewriter in an attempt to forge a typewriter poem back in 1990. at the time my head was newly aswim in all things concrete, and the typewriter poem had firmly established itself as a major corridor in this immense but largely ignored idiom. admittedly, i had no real idea of what i was doing at the time, and consequently it felt pretty far out there to me. at this tender age, i was already no stranger to my own sympathies with things far out: people had, after all, already been making art out of urinals sixty years before i was born, and i knew this. the results of that first encounter — a sleepless night with the house to myself, clacking away on the machine until dawn — slowly leaked out into various plastic poems and collages i worked out over the next few years. in those early days, apart from some extremely raw typings, i also had occasion to conceptualize and execute one of my earliest published works: *dead letter office*, a photo-essay-cum-performance script/document that presented the results of a sledgehammer and some hapless typewriter, which over the course of about an hour and a good forty whacks became reduced to many tiny little pieces, time-lapse photographed one whack at a time. in retrospect, *dead letter office* was the first important work i was able to tease out of the typewriter, and curiously, it had nothing to do

with typing itself. in 1994 i conducted a similar stress test with a typewriter thrown off a high bridge onto train tracks below. the keys from that machine can to this day be found hanging off the spigot in my shower.

later still, i had occasion to occupy a storefront space which had at one time been an art gallery. this was on university avenue in windsor, at wellington, right at this (now gone) infamous hump which would bounce you out of your seat if you drove over it too quickly. in the spring and summer of 1996, road workers had stripped the pavement down to the dirt, and were busy regrading the road over the bridge right at this hump. this was the perfect opportunity to sink a time capsule right there in the middle of the street, before the pavement was replaced, effectively locking it in for good. one fine evening we held a very nice dinner party and for dessert we dug out a suitably sized hole in the street — everyone got to take digs at it — and then very solemnly and very ceremoniously we dropped the typewriter into the hole, reburied it, whereupon it was later unwittingly further covered under a layer of pavement. to this day there exists a typewriter buried under university avenue which i know is there because i put it there.

at that time, in the early to mid-90's, typewriters were still fairly common enough in the culture that they were not yet highly sought after items. this surplus dictated my cavalier destruction of a great many of the poor machines. those, as they say, were different times … i think i then regarded such conceptual extravagances as a means toward an eventual end. i somehow instinctively knew my destiny was to be wrapped up in these wonderful machines, the typewriters. furthermore, i knew i wanted a room full of them if i ever became an adult.

the next corner i rounded occurred at the turn of the century, 1999/2000, when i inherited a beautiful vintage underwood, in near mint condition. it was the first typewriter i had acquired which i felt some affection for, and which i vowed i would not destroy. it was also the first official machine in my now fabled arsenal, and also the first to which i gave a name: Volker Nix. close to around this same time, a very good friend and sometime collaborator, Sergio F., found a typewriter seemingly abandoned on a front lawn in the city of st. catharines. what he got that day was more than he bargained for; it was an olivetti linea 88, and it was this typewriter more than any other which first attuned my eyes to the vast differences in the actual multiplicity of available machines. the linea 88 sported a type that was much larger than that of any typewriter i'd yet seen. it wasn't long before i began

spiriting this machine away from my friend and using it to generate typewriter poems with a new idea in mind: i had begun to conceive of texts issuing out of not one but from several machines, by slow passes through each. i'd come to realize that something altogether unique could be achieved by one versed in typewriter poetry attempting to interface the various machines themselves. (feeding the same piece of paper through a battery of typewriters is how i might explain the phrase 'expanded typewriter', liberally lifted from the discipline of avant garde cinema). in the meanwhile, i knocked out some of my earliest successful typewriter poems using Volker Nix, Linea 88 and a new machine, Monica, an olympia from west germany. these strides notwithstanding, i knew i had yet to hit those superior peaks that i was really after.

in 2005, i got a tip informing me that a strange typewriter was for sale at a local thriftstore. this machine was a remington rand hebrew / aramaic typewriter that had been made in canada. its acquisition into the arsenal was definitely a big move in the right direction for this project. a full decade into my possession of this particular tool, i can say that i am still in process of discovery as to what all i can convince this machine to do for me. but through it, more than any other, i also came to understand that all the machines were like this; they all had hidden reservoirs of tricks hiding in their configurations, a set of occulted secrets known only to a very few. they all required one to be put through steep learning curves in becoming adept at their use. even though every single one was just a typewriter, they all possessed different properties. some had unique keys. some had half spaces. some had long necks. some had tight scrolls, pushing lines closer together, while others were more loose, pulling the lines further apart. all of the alphabets were unique, even if it wasn't immediately obvious at a glance. so i started to really see how each make and model of typewriter brought something different to the table. they were none of them alike. the typewriter poets of lore had somehow not clued in to this. they never once for an instant gave thought to the idea of the expanded typewriter. all those poets who had gone before had remained content to type on and actively champion their one machine, this poet olivetti, that one a baby hermes, etc. what i had sense enough to sense was that through the application of my notions about the expanded typewriter there might be a whole new world out there for the taking, insofar as the marginalized idiom of the typewriter poem was concerned.

it was in 2007, while looking over some older, published but as yet ungathered materials, that i isolated several typewriter poems together for the first time. they seemed to group very well, but i was most struck by one detail, something that had hitherto eluded me: this really

was the first small body of work that i had generated entirely ex nihilo, which is to say, out of nothing. apart from my concrete poems, which numbered in the hundreds, there was nothing confirming my status as a published poet. i had yet to publish what i might refer to here as a regular book of poetry. none of my work at that time or leading up to it had been generated entirely from nothing. the bulk of it had been made using a variety of techniques which amounted to cannibalisms of previous work, of manipulated fragments from found sources, variously corrupted and polluted by my hand, but definite secondary revisitations of older — often artless — artefacts. i then noted, as if for the first time, that with a typewriter poem, one started with nothing — a blank page — and then added only type to it. in this way was i able to see myself plying the craft that got me away from wanting to glue the entire universe down, and began imagining a larger body of typewriter poetry. when *nein typos* was officially released a year later it only fully confirmed everything i had been thinking. the typos did indeed group well together; a much larger book of them would be a great thing to see. how come a bigger book of typewriter poetry had never been written? how come all volumes of typewriter poetry had historically only ever been slim volumes? the initial conceptualization of *clean sails* had begun.

thus began the obsessive quest to locate and gather up as many of the machines as i could lay a hand to. the ritual urban and rural scouring of thrift stores and flea markets became part of my habit and/or routine. with some effort i was able to build up a robust arsenal of these machines. the outward circumstances of my life also changed not so subtly in this time too, when i moved from *chez gargoyle*, a cramped, stuffed to the gills bachelor pad, into *the grove stand*, an actual house. now finally for the first time in my adult life had i the space to realize my adolescent dream of fitting a room chockablock with typewriters. and soon, the 4 or 5 i had grew to be 8 or 9. by the fall of 2009, i managed to acquire several new killer machines, and using these, had coaxed the texts 'a jewel for pirate jenny' and 'dog fucking by barney rubble' into the light of day. these two poems represented the turn in my work i'd been preparing myself to receive for the whole of my life. while i was still not ready to receive this book, the stage was now closer to being set: i now had the first two 'clean' poems for the 'next' book, whatever book that might be.

the tipping point was an art vacation i was privileged enough to be able to take under the auspices of an art star friend of mine, the exemplary neo-expanded cinema projection performance artist Bruce McClure. previously, in 2008 i had occasion to accompany Bruce to the film festival *courtesan* in ghent, belgium (from which the lace witch,

which i did not type) was acquired. in 2010 Bruce brought me along to his gig at *itau cultural* in sao paulo, brazil. i embarked on this trip knowing full well that i'd be paying a visit to one important city in the global development of the concrete poetry movement. little did i know when i left that i'd coincidentally be staying a mere block away from the *casa das rosas*, the archive and museum housing the work of Haroldo de Campos, who, along with his brother Augusto and notable others like Decio Pignitari and Hermelindo Fiaminghi, had formed the nucleus of the brazilian concrete poetry movement in the 50's. down in sao paulo i learned that in brazil, at any rate, their indigenous concrete poetry had been an outgrowth of their own, local 'concrete art' movement — an umbrella for all forward thinking, modernist, utopic leanings in arts, culture, architecture, design and letters then mesmerizing the country. through this lens did my eyes drink in the city. even if it was just a massive case of autosuggestion, everywhere i looked i saw concrete poetry! everything i saw in that huge city invoked if not the spirit of concrete poetry, then at least its many fabled ghosts. upon my return to canada i was feverishly inspired. i had soaked up some sort of charge from the place, and immediately i set my sights on my small but growing arsenal of typewriters, ready now to make something of them.

i had determined that i wanted to bring off a wild work, a work birthed in and informed by the dazzling wilderness that had reared me. i realized that i was in a little room in my forlorn little city, and that what i ended up doing in that little room would make up my art. i clued in to the fact that everybody has a little room, and that all their reports are similarly issued from the confines of those little rooms. for all my lifelong avant grade coordinates, for all the recondite and outré materials i'd spent a lifetime absorbing, these materials hadn't really had all that much in the way of an effect upon my work. i knew i hadn't gone out far enough. but it wasn't just me: everyone was too busy being afraid to go out further. fear actually ruled most people's art! this was something to consider. people were afraid because they were most fearful of being themselves, all alone, up there on the annihilating dividing line that separates centre stage from the audience. no one much cared to signal through the flames, because indeed, some of those flames were hot.

i saw that i really just needed to jump into the fray, and in so doing, i understood that as a matter of fact i did have a voucher for poetry; i'd been reading it and studying it and collecting it for a quarter of a century, and here i was, a man with guts, i thought, actually afraid of my own ability to make something from beyond. yet paradoxically, further out is really where i most wanted to go, regardless of the artificial boundaries of propriety and

decorum, which, if heeded, could only inhibit my mobility across the ranges i wished to explore. it seems to me that when i'm in my little room there really are no limits. it took some effort, but no longer am i afraid of what i can create by my little room, and no artist or writer ever should be. i was very nearly 40 years old before i finally understood that poets have the intrinsic authority to be the poets of their own poetry.

rules were established. i evolved the seemingly arbitrary number of one hundred and eleven poems out of a close reading of Nelson Ball's annotations to bpNichol's *konfessions of an elizabethan fan dancer* (first published by Bob Cobbing in 1967; later reprinted by Nelson Ball in 1973; and then further reprinted again in an annotated, deluxe edition in 2004 — it may very well be the most known book of typewriter poetry from canada? or is that spot reserved for Steve McCaffery's *carnival* panels? its a toss up?) my wish was to write out a body of work with proportions epic enough to carry freight and punch above its weight but not so large as to prevent my meeting the challenge i set for myself. so i started hitting the keys, clacking my way out of my project, watching the poems slowly bubble up one at a time. initially the idea was that i would start and then work at some sort of breakneck speed to carry to completion the entire volume in one fell swoop, the way many a mystery novel had been written. this worked well enough at first, but as i wrote deeper and deeper into the book, newer texts continued to come off better than those which had gone before, and i realized with a kind of alarm how little i actually knew about a subject i'd pretended to know so much about for the past two decades. i had only a superficial understanding of the typewriter and of the typewriter poem itself, and, furthermore, no one really had this understanding any longer. the typewriter had been made to evaporate from our culture like a stain of breath upon a mirror. the problem was that patience and concentration were no longer qualities that anyone possessed. yet these were simultaneously what was most required to bring about excellent typewriter poems. so i spent the rest of the summer in a concerted effort teaching myself how to concentrate, how to be patient and how to meditate a poem into being out of nothingness.

early on i had decided that all the pieces would be composed on regular $8 \: ^{1/2} \times 11$ sheets of paper, no different than any other typed page. by this stage in my development, i had already gone the experimental route of trying out expensive art papers and had determined that those papers were inadequate for these purposes as they did not sit well in the machines, tended to buckle, ruining the overall effect, etc. so regular, plain old drugstore paper was used. however, only a small handful of my typewriters have what i call long necks,

i.e. long paper carriages which wind the paper in lengthwise, to thus disrupt the regular orientation of the page. by poem 80 several years later i was ruing the decision to work with the rectangle rather than say a much simpler square. but i also knew that the more restrictions and constraints i abided by, the better the results would be.

of course, the other rule established was that there were to be no cuts and no glue in any of the pieces. everything would be made manually, one to one, using only typewriters. as a concrete poet with a few decades of slash and burn cut and paste collage behind me, this was a bold move, one i welcomed for the vive la différence it brought to my tiny but growing oeuvre.

before i really had a grip on this project and what i wanted to accomplish by it, i went through a mentally rowdy period where anything went. i played with stencils, just a bit, before determining that this really was a cheat to the variety of clean concrete i wanted to create. i played with experimental transfers, whereby newsprint and other yellow papers were sandwiched between two sheets, then run through the typewriter, leaving a soft edged image in its wake. these too i came to reject. i played with a form of scissoring using the sharper underscores on a few of the typewriters, almost paper doll like in their ability to carve space out of the page. this too i rejected. eventually, almost too easily, i arrived at the idea that many have already made a big deal out of: the *prepared* typewriter. i introduced a redundant typewriter to a dremel, and carved my own mutilated alphabet directly onto the keys themselves. the first one i carved was hastily executed with abandon. i played with this machine for about a month before concluding that, while it was a good idea, i hadn't executed it carefully enough. by Legba Two, i had plotted the reductionist cuts i would make on the keys. these were close to being the last acts right before the project stalled. three years later, while playing with Legba Two, i discovered *the mice*, hiding in the configuration i had carved years earlier. what a gift to myself! however, like all these tricks, i came to reject the mice too, somewhat. similarly, i restrained myself from carving up all my typewriters, thereby berthing a flotilla of mutilation. for the purposes of this project, two were enough. i had figured out how to prepare a typewriter so that it might yield up to me further secrets. as far as i know, this was another first in the world of art, let alone concrete poetry, where supposedly everything had already been done well before any of us were born.

word of the project was slowly leaking out into the small world of interested parties. a gig came up in 2012 which brought me out west to vancouver, where i first crossed paths with

the publisher of this book, Rolf Maurer. he expressed interest in these poems, and although it was still only half done, seemed to want the manuscript right away. it would take me 16 months of aborted attempts to get back in good with this project. i still had to go through a lot of thinking before i was even close to being mentally prepared enough to finish what i had started. in the intervening time between part one and part two in this book, i took many notes, furthered my thinking on what it was that i really was doing, and seemed to get a better handle on the book i was writing. most importantly in this time, now that my interest had been total and confirmed, i was able to gather together further models of typewriter. the 8 or 9 i had turned into 14 or 15, and then went on to become 18 or 19. at the end of *clean sails* i can say that the arsenal now houses 24 typewriters, and that no less than 35 machines have touched down onto the pages of this book to become implicated in the project.

i began this book by setting an almost impossibly high bar for myself. now that i've come to its end, i've gained a deeper appreciation for all that remains to be done: there is much terrain left to map throughout this unknown world i've discovered. at the beginning, what i most wanted to do was rehabilitate the typewriter poem, to write out a major volume of typewriter poetry, one so imposingly sturdy it could never again be casually dismissed, routinely ignored or denied a place at the cultural table from which it had in the main been excluded, getting on one hundred and twenty years (since Stéphane Mallarmé (1848 : 1898), at the very least). in crossing my own impossible finish line, what i've come to understand now is that the project concerns the rehabilitation of the typewriter itself, and not just its thin branch of poetry. which is a very pleasant place to be dropped off at this book's conclusion. i have not exhausted the typewriters by any means. if anything, i'm only made that much further aware of just how great and large and vast and unexplored this desert/tundra i've been wandering around in actually is. and with a mere 24 machines in my arsenal, it seems certain i will only continue to gather models with the passage of time. newer models will mean more poetry, further instalments of this project, a project likely to preoccupy some of my attentions for the remainder of my life. soon enough, after a long and necessary vacation, it will be time for me to build the next ark …

 gustave m.
 september / 2015
 the grove stand

when birds turbine, knacker squirms: a note on concrete poetry

i'm all for pushing poetry; sometimes its lazy and needs a good shove.

i'm all for events and for horizons; but also for event horizons. i'm also all for the frontiers, and for the people who come to chart them, defeating the anxiety of their influence. what we get out of any exploration is what we think we're looking for, otherwise we wouldn't explore anything.

i learned long ago that i would never set the world on fire, and i'm resigned to that. what is good can never be popular and what is popular can never be good.

when the conceit of communication as useful activity is removed, or at least temporarily lifted, i think what's left is the little haunted house that poetry is permitted to occupy. obviously poetry, in our post-post-modernity-what-the-fuck-clusterfuck, finds itself placed in a ghettoized space, socially, politically, economically. making more inviolate my own particular ghetto has been one of the aims of my own concrete. that is, not only constructing the forms themselves but bodily defending the actual space these unauthorized formations require to stand. gainsay who dare …

we've known forever that art is biologically useless. what's lesser known is the paradox that, however useless, it can still be put to many other uses not related to our biology, and is immanently useful in precisely these other areas; viz., our intellectual life, as an extension of the good life we enlightened ought to be attempting to lead once our gullets are oriented, et cetera. we can't eat art but it will nevertheless always manage to find ways of sustaining us. craft isn't everything, but nor is it a service.

when concrete poetry is dismissed as being 'the t.v. of literature', as it has, i'm left with some hope for the future of literature. people at least still know what t.v. is, and they haven't forgotten that they like it.

my own dim wisdom tells me that none of any of it is important in 'the scheme of things', while my pesky vanity implores me to shout 'the scheme of things' would be so much worse for wear if no importance at all were attached to even the lowliest thing, which concrete is not.

after all this movement, which is a species of friction, what i think i'm after, very simply, is to see something i've never seen before. and i want to write the books i cannot find in the library, just like eric blair. its really terribly simple. and painfully real.

gustave m.
march / 2013
the grove stand

acknowledgements

thanks are due the *Ruth & Marvin Sackner archive of concrete and visual poetry* in Miami, Florida for their demonstrated support of these poems, of this project, but also most importantly of their support of the intrepid correspondent responsible for both

thanks are also due Ross Priddle of the *bentspoon arts council* for (once more, with feeling) several generous helpings of guns and butter over many years, et cetera

some of these poems broke away from the herd and thus committed prior offences in the pages of the following journals, magazines, anthologies, newspapers, pamphlets, fly sheets and other ephemera: *brick books* (london), *the capilano review* (vancouver), *carousel* (guelph), *culture xl* (edmonton), *cyphers* (dublin), *experiment-o* (ottawa), *fhole* (toronto), *gar* (calgary), *geist* (vancouver), *hat* (medicine hat), *illiterature* (kingston), *the lance* (windsor), *letterfounder* (lewiston), *node pajomo* (bellingham), *otoliths* (queensland), *queen street quarterly* (toronto), *quill puddle* (detroit), *rampike* (windsor), *sequence* (big ben london), *tip of the knife* (oakland) and *xtant* (roanoke)

in *detours: an anthology of poets from windsor / essex county*, eds. Dawn Kresan & Susan Holbrook, palimpsest press, Windsor, Canada, 2012

in *prose karen: for pleasure, against kapitol*, edited by Marshall Hryciuk, nietzsche's brolly, Toronto, Ontario, 2007

in *typewriter art: a modern anthology*, edited by Barrie Tullet, lawrence king publishing, London, England, 2014

in *the art of typewriting*, edited by Ruth & Marvin Sackner, thames and hudson, London, England, 2015

nein typos was issued as a handsome portfolio in 2008 under the aegis of Reed Altemus through tonerworks of Portland, Maine

small fry was issued as *gar* # 90 in march, 2012, Calgary; reprinted as *stained paper archive tract* 10 in may, 2012

knull and vortext appeared as *stained paper archive tract* 14 in may 2013

flea circus was issued as *gar* # 118 in may 2015; reprinted as *imprimerie espontaneo fly sheet* # 1 in july 2015

33 typos was privately issued in 2011

44 t-poems was also privately issued in 2015

the monolith bracketing the entr ' acte can be found in Frances Kruk's chapbook *down you go, or, négation de bruit (après danielle collobert)* published by *punch press / damn the caesars*, Buffalo, N.Y., 2011

thanks to Max Middle of the *ab reading series* at Ottawa for graciously hosting "the largest survey of my concrete ever attempted" in april 2011

thanks to Donato Mancini for inviting me to give a similar slideshow-talk at the *kootenay school of writing* in Vancouver in november 2012, and in so doing, for exposing these poems to this publisher

thanks to Louis Cabri of the *satellite reading series* at the university of windsor for a further engagement; and to *artcite inc.* for hosting the event in march 2015

thanks to Patricia Fell and Trevor Malcolm of the *windsor feminist theatre* for generously extending to me an artist residency as part of the *pelee island music series* in july 2015; thanks to Collette Broeders for being my art chum at the captain's quarters for the week

thanks to Bruce McClure and Robin Martin for several extremely kind gifts which i may not ever quite be able to properly repay in full (cf. witch patch of Ghent, et cetera

thanks to the *festival courtisane* in Ghent, Belgium and to the *on/off festival* at itau cultural in Sao Paulo, Brazil, for hosting Big Bruce and Little Bruce in 2008 and 2010 respectively

thanks to Lori & Paul Kimmerly of *standard printing inc.* of Windsor for what has grown to become many years of excellent printing, many happy et ceteras

thanks to Jarrod Ferris, my comrade at *23 skidoo!*, for his many splinters from tripods, with hopefully many more to come

thanks to Tony Mosna and Marty Hunt for showing me the preparatorial ropes and providing me with exemplary eleventh hour rescue operation management skills at the agw while i was semi-employed there off and on throughout the oughts

thanks to Jeremy Rigsby and Oona Mosna at *media city* for permitting me to piggyback certain of my books on the shoulders of the festival these many years

thanks to Luke Daly and to Angee Lennard at *spudnik press* in Chicago for a few good gigs

thanks to Gabriel Saloman & Aja Rose Bond at the *stag library* in Vancouver

thanks to Meghan Forbes of the *harlequin collective* in Berlin, Brooklyn and Ann Arbor

thanks to James Hart the 3rd and to Kim Hunter at the *woodward line reading series* at the scarab club in beautiful downtown Detroit

thanks to Kero and Annie Hall at *riverside records* in the Dub for threatening to adorn record sleeves with some of these typos

thanks to Frances Kruk for meeting me halfway, once, many years ago

thanks to the not guilty Derek Pell for his back cover blurb

thanks to the late Bruce Connor (1933 : 2008) for his invention of the protective rat bastard seal

thanks to the late F.A. Nettelbeck (1950 : 2011) for the broken t.v.

thanks to jwcurry, Daniel f. Bradley, Nicky Drumbolis and Hart Broudy for leading by example in a country bereft of true leadership

thanks to the moths, both real and imagined: Rob Read & family (Julie, Ashwin, Orrin and Aravyn); Marshall Hryciuk & Karen Sohne, Oia Roldan (and e!); John Barlow, Kevin Thurston; Matt Chambers; Sara Jane French; Amie Carson in Texas; Carlyle Baker; David Baptiste-Chirot; AEM; Sean Bonney; Jennifer Books; Giovanni Sampogna; Sam Kaufman & Rebecca Houwer; Peggy Lefler; Troy Lloyd (wherever he is!); Greg Evason; Jim Lowell (1932 : 2004); Karl Jirgens; Mark Young in OZ; Paul Hegedus; David Fujino; Bill DiMichele; Crag Hill; Roy Arenella; Paul Czank; M.Kettner; Theo Green; Nelson Ball & Barbara Caruso (1937 : 2009); Jesse Kendall; PJM; Cameron Terhune in the big house; R.F. Cote and Carolyn 'Kerosene' Ord in Quebec; Mike Borkent; Amanda Earl (& Charles!); John W. MacDonald; Natasha Cuddington; Michael E. Casteels; Judith Copithorne; Mark Laba; Dorothy Trujillo Lusk; Catriona Strang; Elizabeth Bachinsky; Brandon Walley; Simon Payne; Julie Murray; Pablo Mazzolo in Argentina; Kevin Jerome Everson; Denis Robillard; Bill Van Wyck; Liam McDermott; Alan Flint (wherever he is!); Andrea Slavik & Jen Slotterback; Sasha Opeiko; Phil Beaudoin; Sean Barry; Dave Fine; Phog Lounge/The Eclectic Cafe; Lee Elmslie, Christopher Mangin and Sergio Forest

thanks to the whole of my small family, but especially to Viki & Steve, my parents; and to Simone Hein, my nanny

the biggest thank you is held in reserve for my sweetheart, Jenny K., the most beautiful typographer in the world, and the real 'without whom not' hero of this book. she snapped pix, she set type; she gave up lots of room at the grove stand to house the arsenal (and stubbed many a toe in the process); and she more than any other has stood by me on the 5 year journey of bringing this book up from the fire and through to the press. thank you Pirate Jenny! xoxoxo

NEW STAR BOOKS LTD.
107 – 3477 Commercial Street | Vancouver, BC | V5N 4E8 | CANADA
1574 Gulf Road, #1517 | Point Roberts, WA | 98281 | USA

newstarbooks.com | *info@NewStarBooks.com*

Copyright Gustave Morin 2015. All rights reserved. No part of this work may be reproduced, stored in a retrieval system, or transmitted, in any form or by any means, without the prior written consent of the publisher or a licence from the Canadian Copyright Licensing Agency (Access Copyright).

We acknowledge the financial support of our publishing program by the Government of Canada through the Canada Council for the Arts and the Canada Book Fund, and the Province of British Columbia through the British Columbia Arts Council and the Book Publishing Tax Credit.

Cataloguing information for this book is available from Library and Archives Canada, **collectionscanada.gc.ca**

ISBN 978-1-55420-108-2
Typewriter Poetry.

Cover and interior design by
Mark Laliberte for Obscure Design
/
gustave m.

Printed and bound in Canada by Imprimerie Gauvin, Gatineau, QC

First printing, November 2015

Gustave Morin makes his happy home at The Grove Stand — located on the outer edge of The Sun Parlour of Canada — in the frontier metropolis known as Windsor / Detroit. There he is deeply involved with *Common Ground*, an art gallery; *Media City*, a film festival; *Imprimerie Espontaneo*, a publishing enterprise; and *23 Skidoo!*, an independent film ensemble. In addition to these many dark arts, he holds a fireworks operator certificate and is a member in good standing of both CUPE 543 and I.A.T.S.E. local 580. Oi ! to the savant garde !